The Lost Christmas Gift

Published by
Princeton Architectural Press
37 East 7th Street, New York, NY 10003
Visit our website at www.papress.com

Editor: Jennifer Lippert
Design and typography: Paul Wagner
Interior layout: Andrew Beckham

Special thanks to: Bree Anne Apperley, Sara Bader, Janet Behning,
Nicola Bednarek Brower, Fannie Bushin, Carina Cha, Andrea Chlad,
Russell Fernandez, Will Foster, Jan Hartman, Jan Haux, Diane Levinson,
Jacob Moore, Gina Morrow, Katharine Myers, Margaret Rogalski,
Elana Schlenker, Dan Simon, Andrew Stepanian, Sara Stemen, and
Joseph Weston of Princeton Architectural Press
—Kevin C. Lippert, publisher

Library of Congress Cataloging-in-Publication Data
Beckham, Andrew, 1969–
The Lost Christmas gift / Andrew Beckham. – 1st.
 p. cm.
ISBN 978-1-61689-102-2 (alk. paper)
1. Beckham, Andrew, 1969–2. Artists' books—United States.
3. Christmas. I. Title.
N7433.4.B43L67 2012
709.2—dc23
 2012008798

The
LOST
CHRISTMAS
GIFT

Andrew Beckham

———

PRINCETON ARCHITECTURAL PRESS · NEW YORK

INTRODUCTION

Emerson Johansson has been a family friend for as long as I can remember. Older than me by nearly four decades (I was a boy when I first met him), Emerson was a warm and thoughtful man who always took the time to ask about the current boyhood project or adventure I was engaged in. It was many years later when he asked me a very different question, to help him tell about a boyhood adventure of his own. *The Lost Christmas Gift* is a family heirloom Emerson received unexpectedly, and one that he wanted to share with the whole world.

We sat down over a series of autumn afternoons and he talked about the experience of recovering the artifact, unpacking and examining it for the first time. As the history of this object revealed itself, so did Emerson's recollections of his own childhood, and the extraordinary experience he had with his father one Christmas long ago.

I recorded and transcribed those conversations, for they have become a critical part of the completed manuscript. You will find Emerson's voice in the first person throughout the book, providing commentary and reflection on this genuinely miraculous story that I am delighted to present in published form for the first time.

—Andrew Beckham

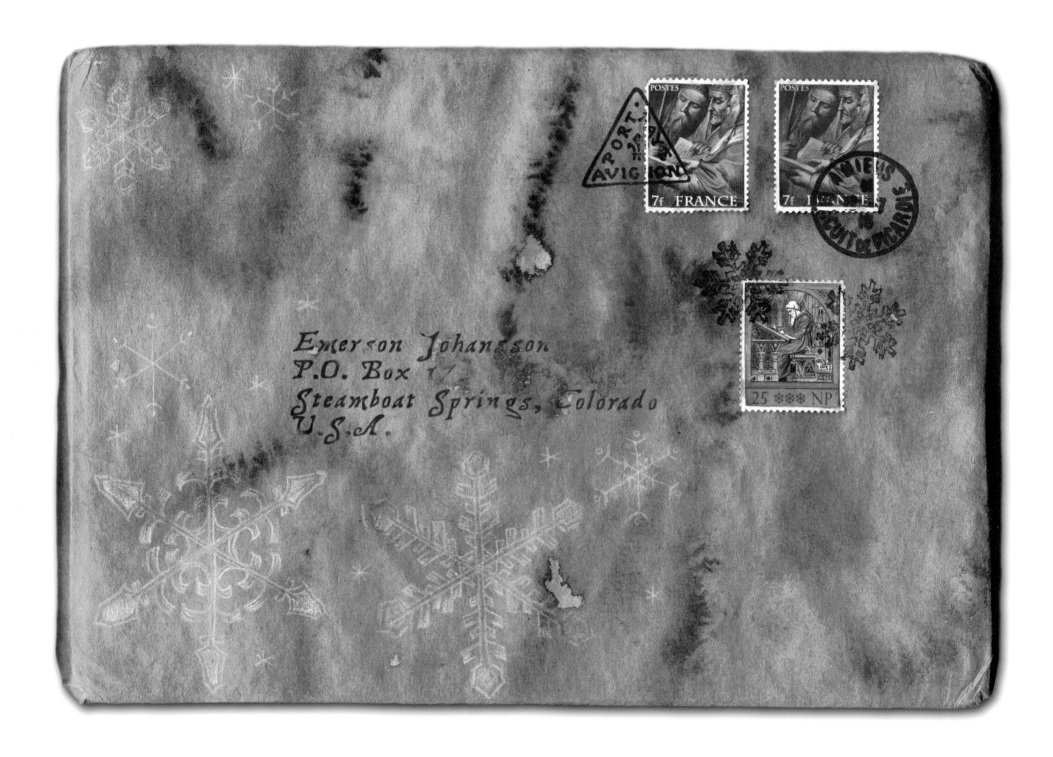

Emerson Johansson
P.O. Box ??
Steamboat Springs, Colorado
U.S.A.

6

ON DECEMBER 23RD, a package arrived in the mail. It was addressed to me, written in the unmistakable script of my father's hand. Now I know this does not sound out of the ordinary; it was Christmas time, after all, when packages arrive in the mail with some regularity. But this was no ordinary package. You see, my father had lived a long and beautiful life, and a few years ago he finally passed away peacefully at the age of one hundred and three. What made this package extraordinary was that it was many decades old itself, as evidenced by the antiquated postmarks on its brittle surface.

My father was called away to war when I was eleven years old. This package, as I reckon it, should have reached me that Christmas, while Father was overseas. Lost all those years, and now it arrives! He never said anything about it to me, even after he returned home. Maybe when he realized it was lost in the mail, he didn't want to disappoint me, and so kept silent.

I live in the family house now, having moved from Denver back into the mountains where I grew up. On the same kitchen table where I sat as a youngster the package now sits, waiting to be opened. Memories flood back, and I almost tremble with excitement to open this lost parcel that was meant for me as a boy…

My Dear Emerson,

I wish nothing more than to be with
you and your mother at Christmas,
but this year it cannot be so. I
have been stationed some miles from
the front line, and my work as a
cartographer helps me feel that I
am helping in some small way.

I have not forgotten our adventure
last Christmas! In fact, I have
found time between shifts to make a
small book recounting our trip.
Its making has been a blessing to
me, for it has helped me to stay
close to you, remembering and
putting down on paper our shared
adventure. In the same way, I hope
this small gift will remind you of
our time together, and help you to
feel a little closer to me this
Christmas, when I am so far away.

All my love,

Father

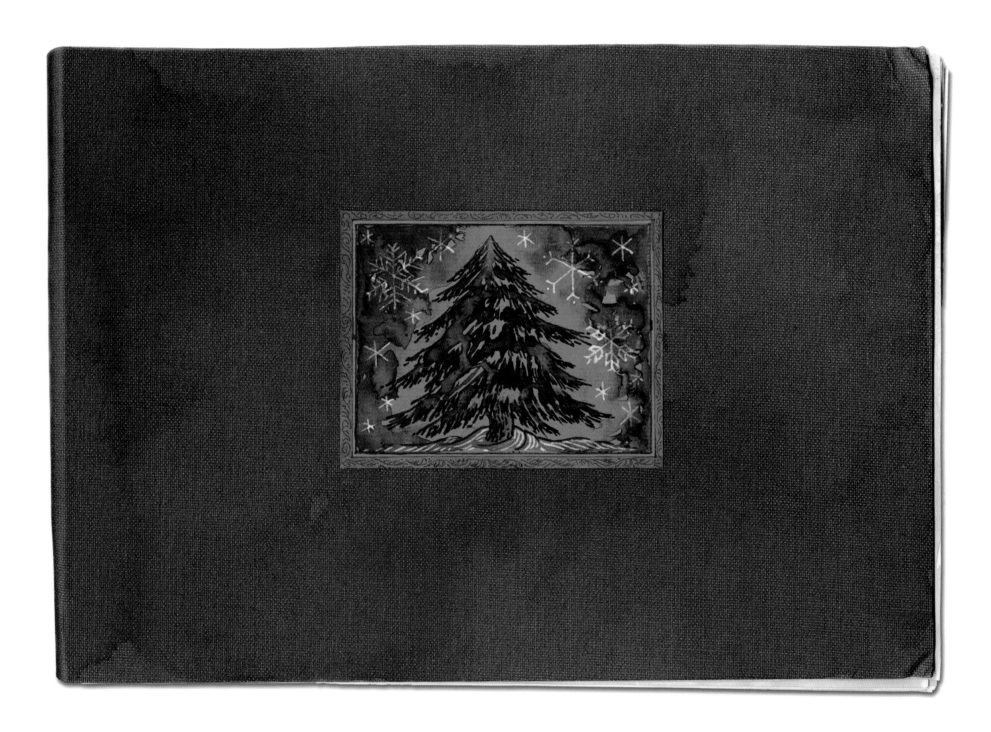

My camera, closed and open! That my father rendered it in such exacting detail from memory is testament to just how keen an observer of the world he really was. An early "compact" field camera, it took glass plate negatives that we had to mail down to Denver to get developed.

I wonder. The story my father begins to tell here most assuredly involves this camera, for I made some pictures that, at the time of their taking, seemed miraculous. But as I recall, they didn't turn out well, or at least I thought so as a boy. And years later I have been unable to find them, which has always upset me.

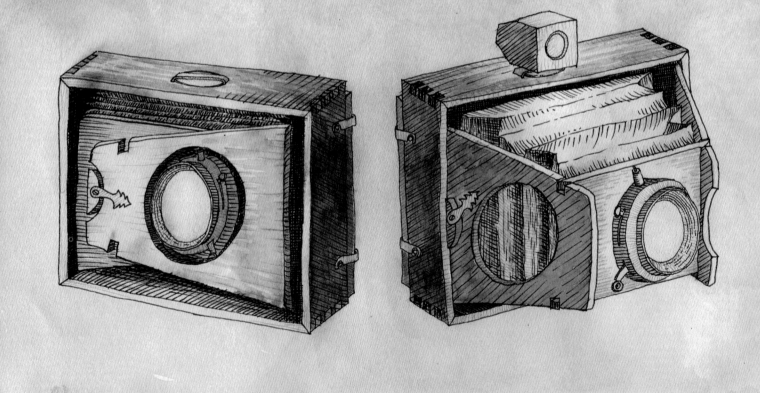

It was a fine winter's morning, and Emerson was excited. The day was December the 23rd, and he was going up into the forest with his father to find just the right tree. Emerson was also excited because he could try out his new camera. It was an early Christmas gift from his uncle, and one that Emerson had dreamed about all year.

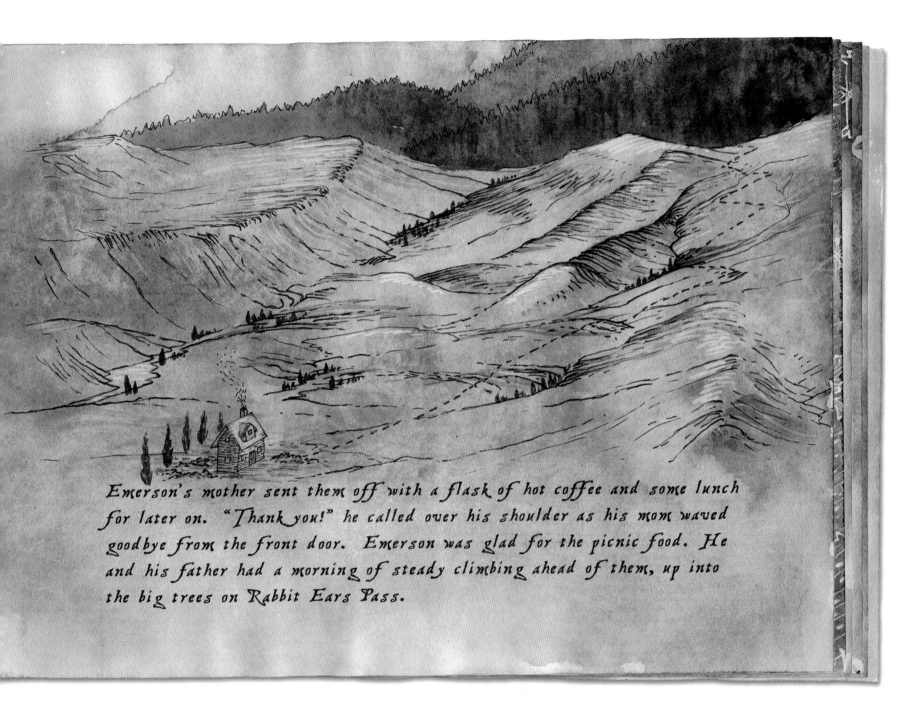

Emerson's mother sent them off with a flask of hot coffee and some lunch for later on. "Thank you!" he called over his shoulder as his mom waved goodbye from the front door. Emerson was glad for the picnic food. He and his father had a morning of steady climbing ahead of them, up into the big trees on Rabbit Ears Pass.

As he said in his letter, Father was a cartographer by trade. Back in those days, that meant hand-drawing the maps, sometimes from direct observation in the field. I think Father was really an artist, though he never talked about his work that way.

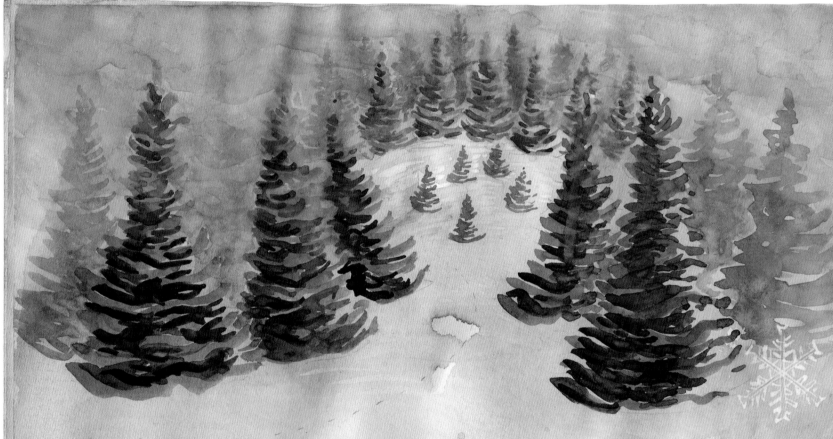

At noon, clouds started moving in, grey and heavy. "Looks like it could snow," said Father. They ate their lunch and watched the first flakes begin to fall. The hot coffee warmed them up, but Emerson was concerned. "We still haven't found the right tree," he worried. His father smiled. "We will. Just up from here there's a stand of young spruce. One of those will be just right."

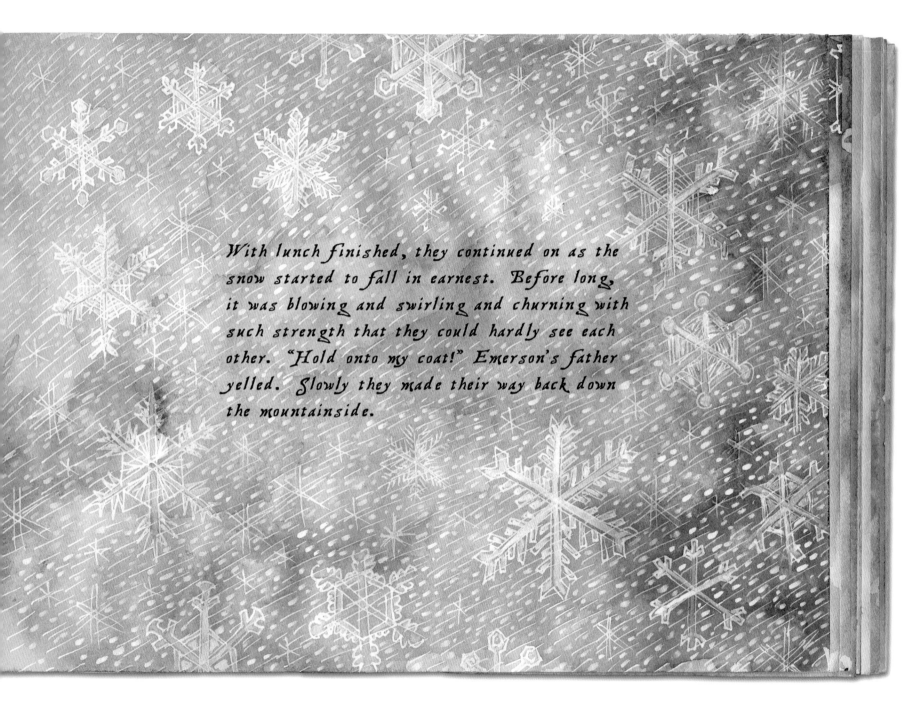

With lunch finished, they continued on as the snow started to fall in earnest. Before long, it was blowing and swirling and churning with such strength that they could hardly see each other. "Hold onto my coat!" Emerson's father yelled. Slowly they made their way back down the mountainside.

My memory was not of holding onto his coat. Father's free hand was wrapped so tightly around my wrist, I could feel the rhythm of his heartbeat pulsing through his fingers. I think he must have believed that if he let go, he would never have found me again…

After some time, the snow let up a bit and they could see their surroundings. "Dad, do you know where we are?" Emerson asked. He sounded scared, and his voice was shaking from the cold. His father looked around, and for a while he didn't say anything. Then quietly he spoke: "I think we must have gotten turned around in the storm, Son. I don't know this place. I think the most important thing we can do now is to find a spot to dig in for the night."

Emerson was still scared, but he trusted his father, who was a skilled woodsman. He helped to dig a deep hollow in the snow, and cut large branches from the nearby spruce trees to use as both bedding and roofing. They tied rocks to cord and hung the weighted ends over the edge of the green roof, to keep it in place should the wind pick up. Emerson took his camera out to make a picture of their shelter, when he saw a strange sight.

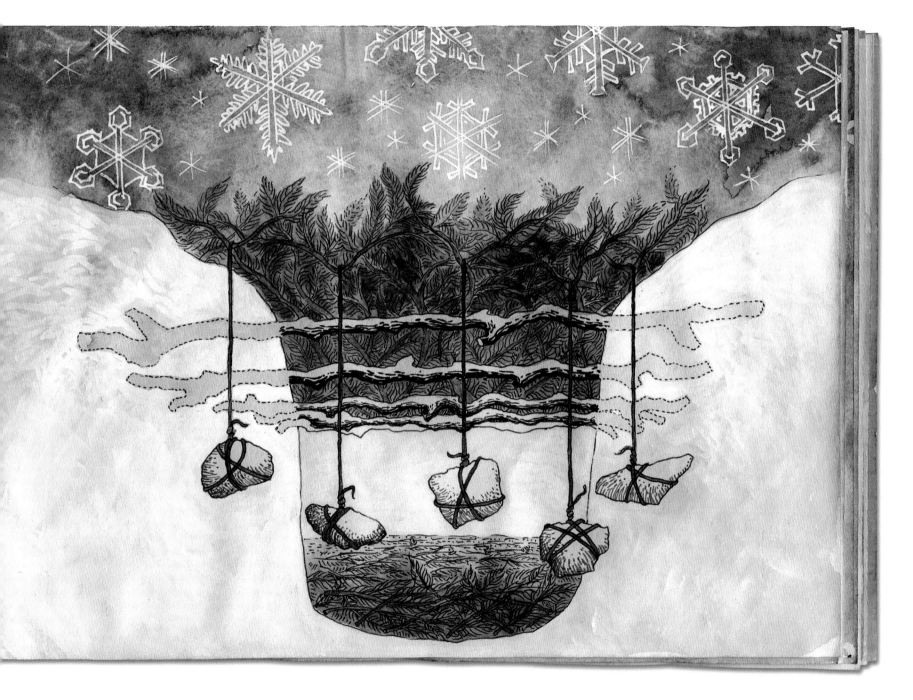

In the woods behind their bivouac was a man,
bent and fierce. Emerson snapped a picture
as his father called out to the stranger,
thinking that perhaps he was a
trapper coming down out of the
mountains for the holidays. But
no sooner had his father spoken
than the man disappeared into the
dusky shadows. They struggled
through the new fallen snow to find
the fellow, but to no avail. "Look
at this!" Emerson exclaimed as
he picked up a small bundle of switches.
The wood was about the circumference of
a man's thumb, and dry as dust.

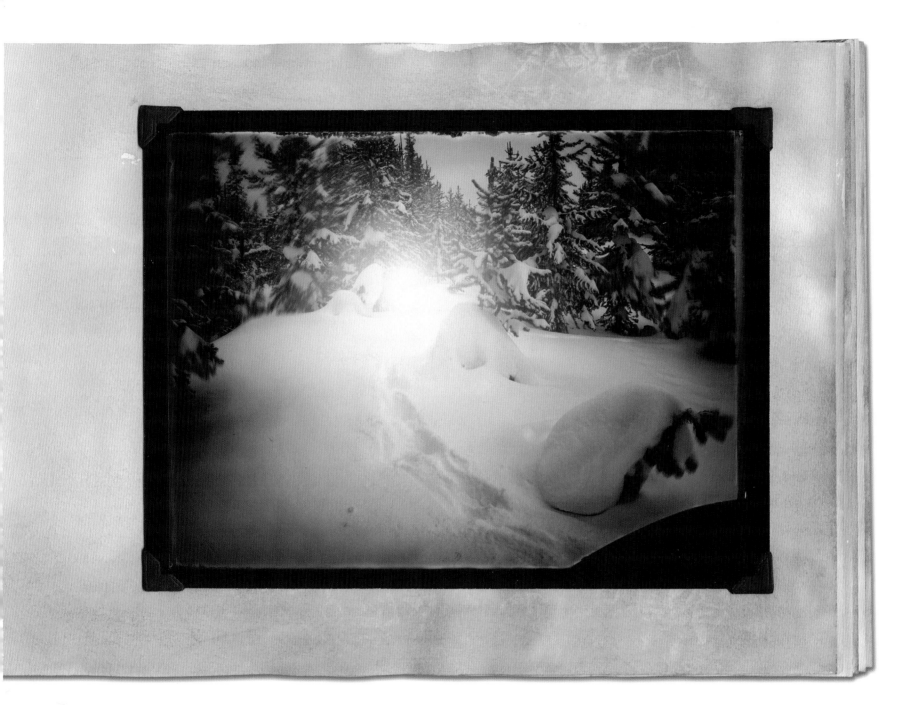

This is my photograph! So here is a mystery solved: my father took the photos without telling me, intending to send them back as a gift! To see this image again after so many years brings revelation, not disappointment. I thought at the time a mechanical failure, perhaps a faulty shutter or some defect of the lens, was to blame for the starry flare that obscured the strange traveler. Father knew better. A camera records the play of light on the physical world, nothing more. My father used his drawing ability to record the mysterious nature of our encounter and make it visible, in a way the camera could not.

As they stood there wondering about this strange gift, they saw through the trees yet another fellow, covered in soot and ash like a chimney sweep. "Is that him again?" Emerson whispered. "I'm not sure," Father replied, "This is strange indeed."
As before, when they called out to the wayfarer, he moved off into the woods at a pace lively and quick, and they dared not follow into the waning light. Again Emerson found curious gifts: small lumps of coal, roughly hewn and stacked in a small pile.

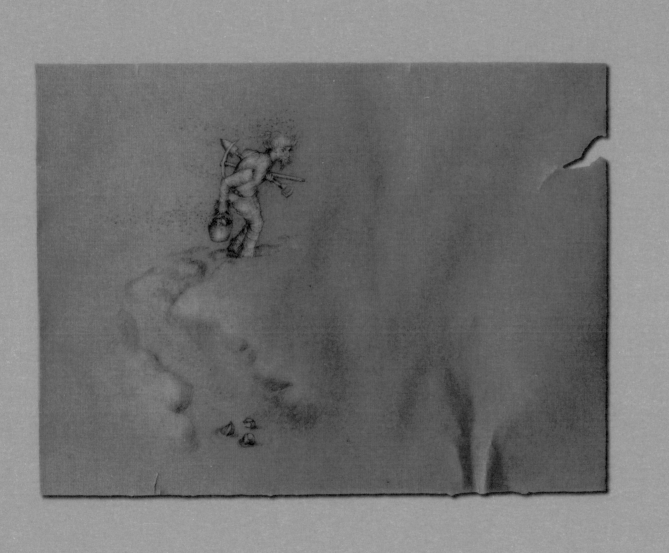

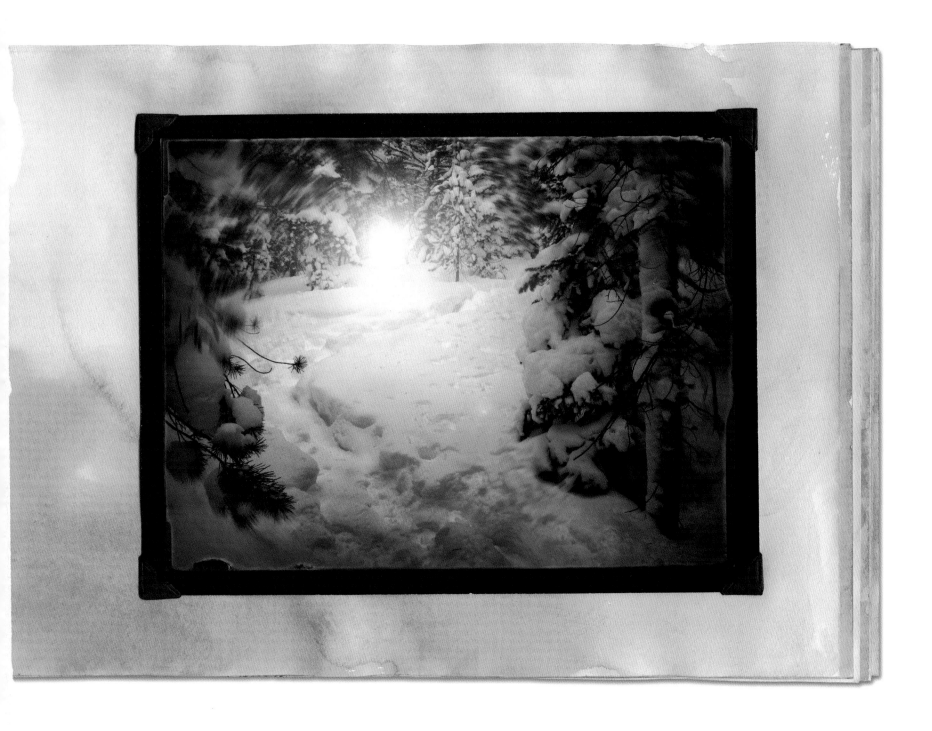

It's strange, but
I had such a different
impression of the
shadowy wayfarer we
witnessed. The first time,
I hardly saw him at all
in the fading light.
A robust white beard I
remember, nothing more.
The second sighting I
remember only his boots,
stout and black, stomping
through the fresh snow.

I really don't know how
Father could have recalled
such detail. Perhaps
his adult and paternal
concerns colored his
impressions: his drawings
depict such rough, almost
scary figures! But I do
remember the hair on
the back of my neck
standing up—there was
something powerful and
deeply arresting about
that wintery traveler…

Back at the camp, Father suggested that they start a campfire. "But all the kindling is under the snow and will be soaking wet!" exclaimed Emerson. "True," said Father, "And anything we could cut would be too green to burn. But what about the switches and coal?" They used only a very little of each, being mindful of the long night ahead of them. As it turned out, that tiny fire burned with such a warmth that Emerson and his father didn't notice that the temperature was plummeting under that frozen, starry sky. They added a little of the coal and switches as the night wore on, and Emerson finally fell asleep curled up against his father, who was soon fast asleep himself.

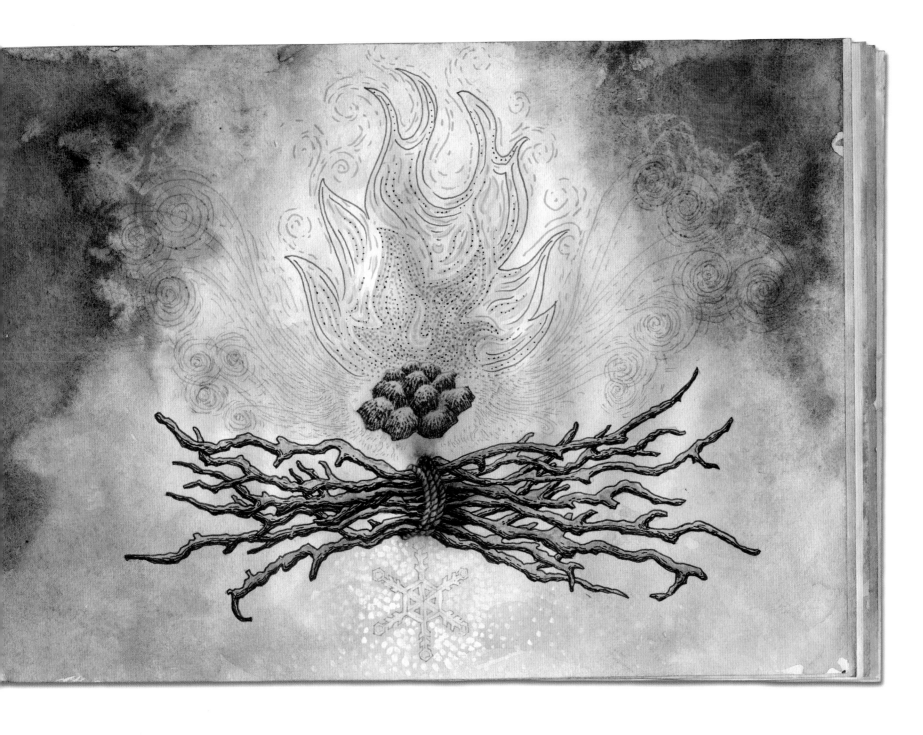

My father must have learned about the official temperature later: that winter had some of the coldest on record, with the night we were out registering a frigid −38°F.

When they awoke it was morning. The embers of the fire were still emanating an uncanny warmth. Emerson rubbed his eyes and looked around, taking in the immensity of the new snow and the beauty of the flocked trees reaching up towards the light in the east.

But it was what he saw close at hand that surprised him the most. "Dad!" he exclaimed, "Look at these! Where did they come from?" Two pairs of Norwegian Skates were standing upright in the snow, wooden and richly carved. One pair was shorter, and the bindings smaller. "Son, do you remember what day it is?" Father was smiling broadly now, and Emerson realized with a start that Christmas Eve had arrived!

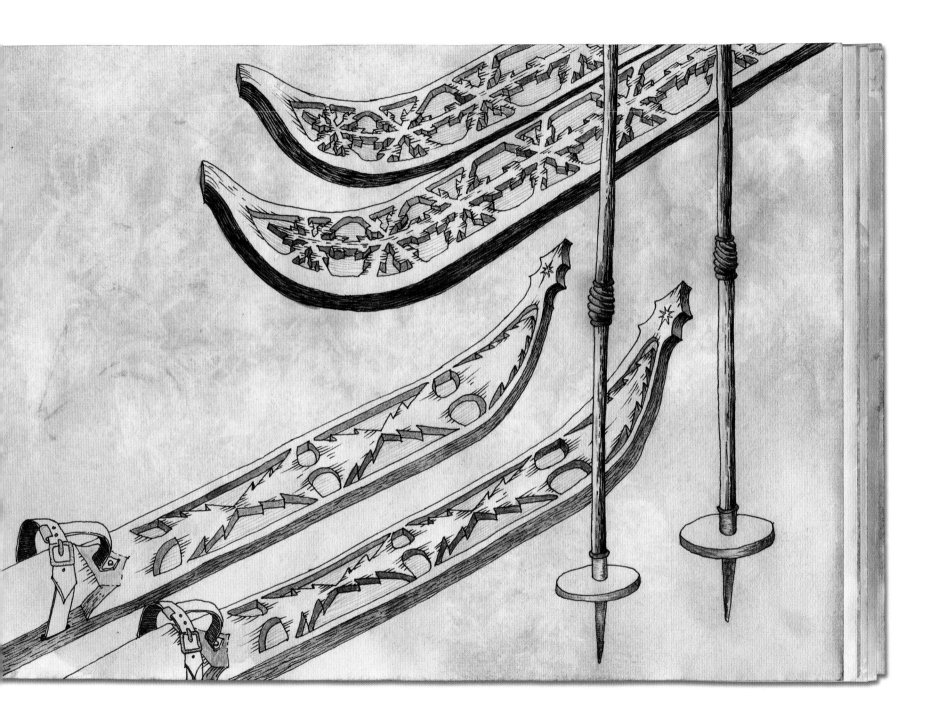

Back then, the term *skis* was just beginning to be used. These were "long snowshoes," from the Telemark region of Norway, also known as Norwegian Skates.

They understood at once that they could not have walked
two steps past their excavated camp without sinking
waist-deep in fresh snow, much less wade through miles
of it trying to find their way home. The skis changed
all that.

They had just set out when off in the distance they
spotted another skier, moving with such grace that
he seemed to be almost floating above the snow.
"He knows the way back!" Emerson shouted,
and sped off in pusuit. Father
came on behind, and soon they
were within a snowball's throw
of the stranger. He stopped
in a deep glade for a moment
before disappearing into the timber.

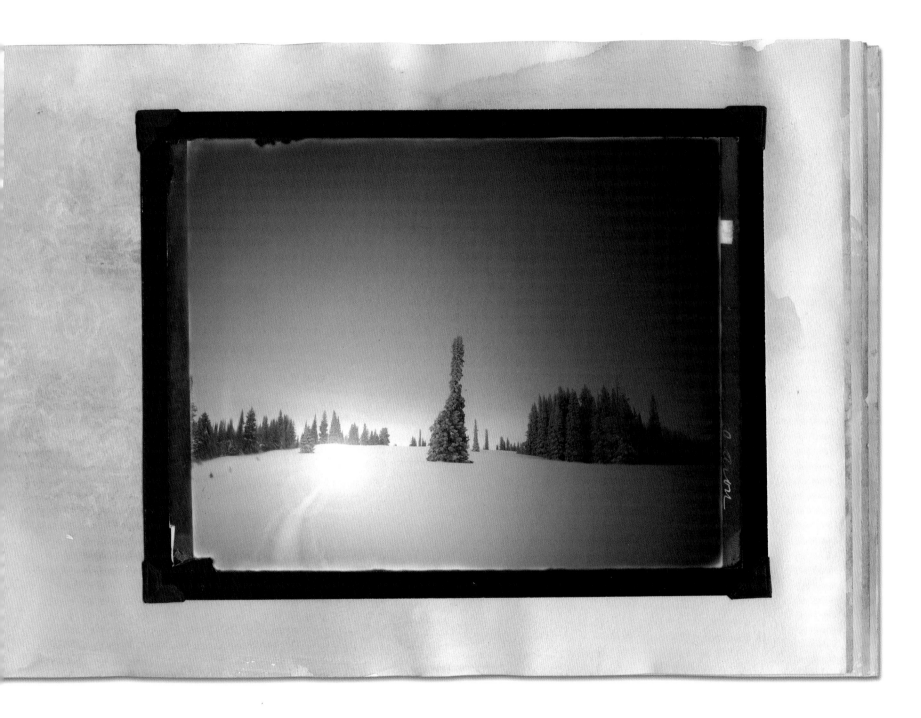

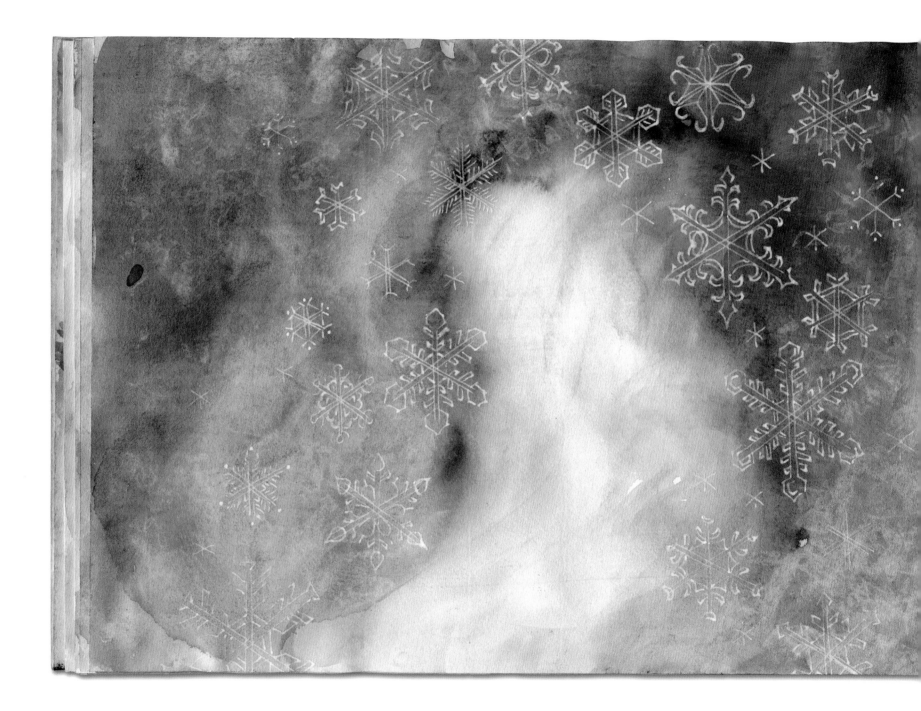

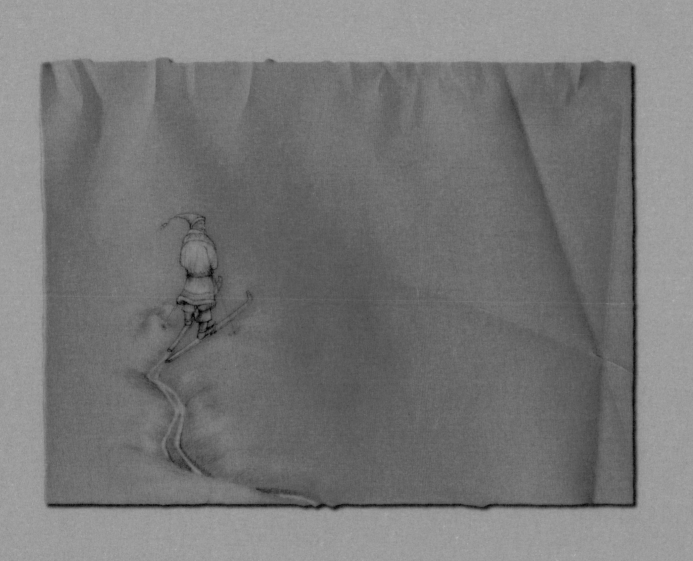

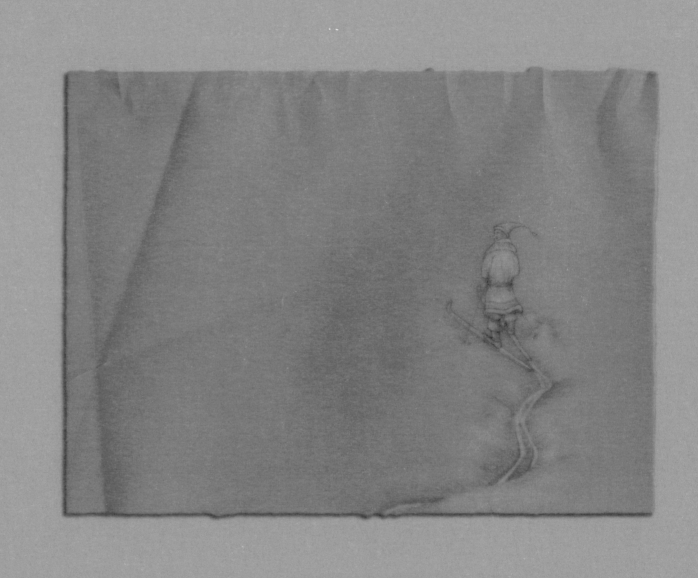

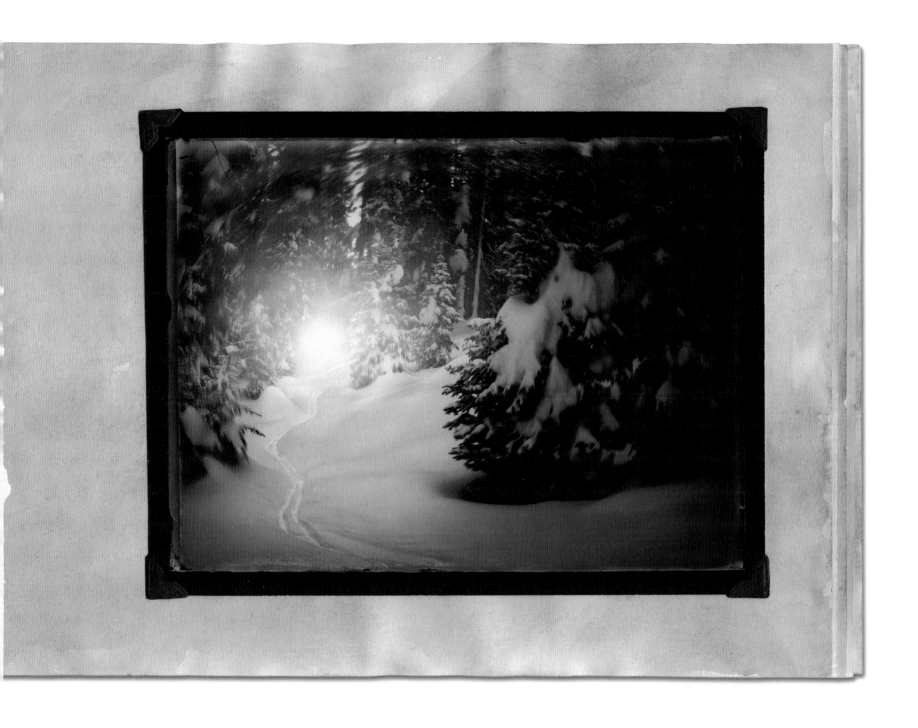

Emerson and his father followed the tracks
until the woods opened into a meadow, and
there he was, cinching up a large bag
that he then loaded onto the sled. St.
Nicholas moved his reindeer just above
the ground, and off they sped! It
sounded like the rustling of dry
leaves and grew to a gale as they
sped out of sight. This time it was
Father who said, "Follow him on!"
And so they skied back into the trees
as the sled flew overhead, and then
finally out of the woods and across the valley
where they could see the lights of their house
twinkling in the distance.

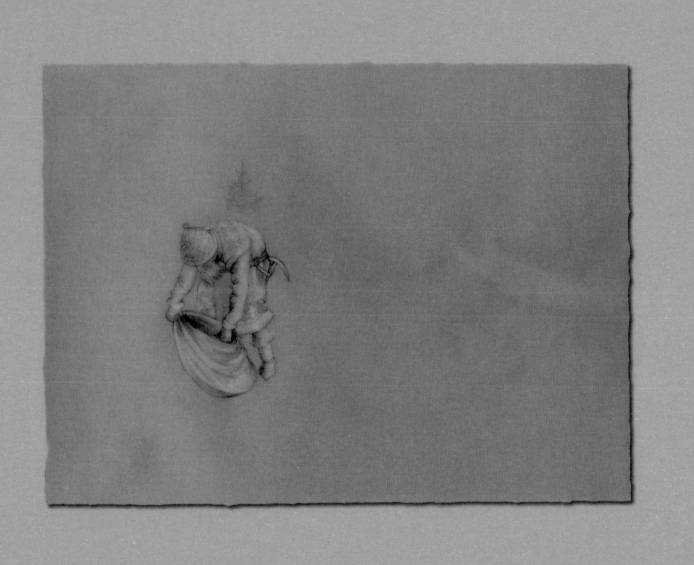

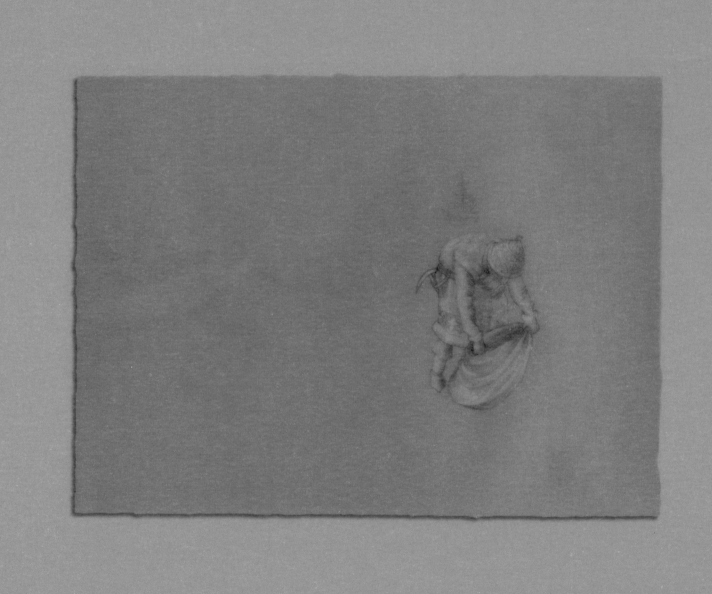

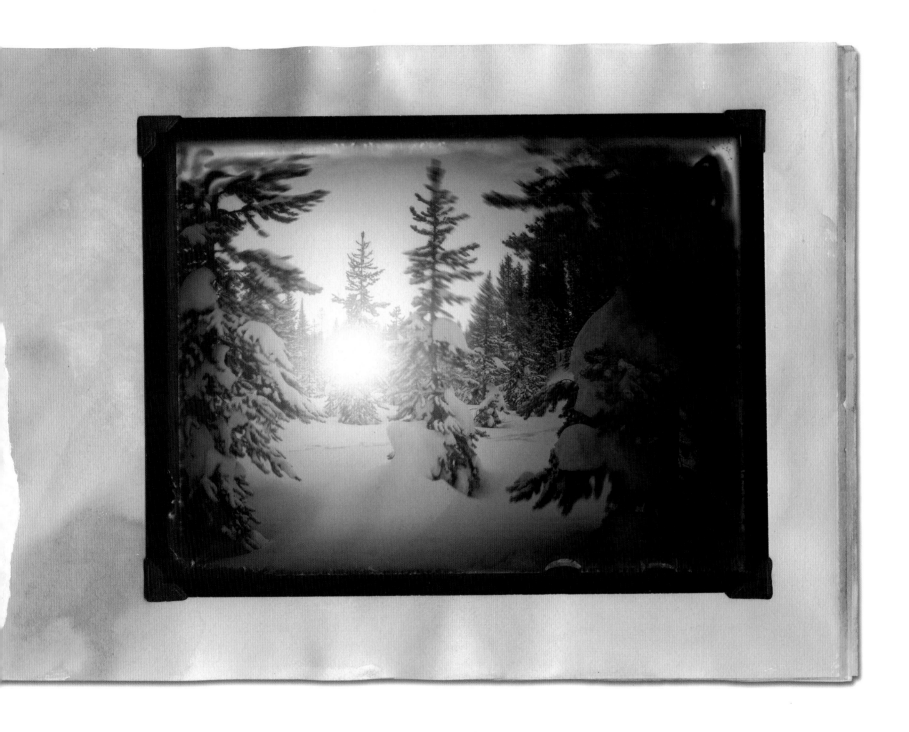

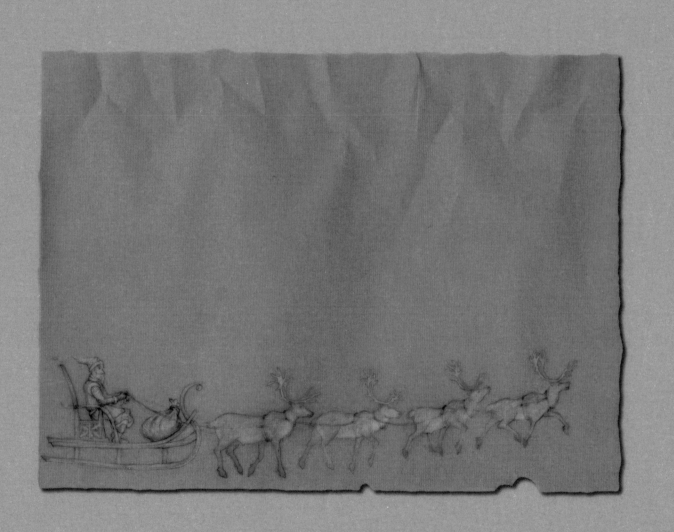

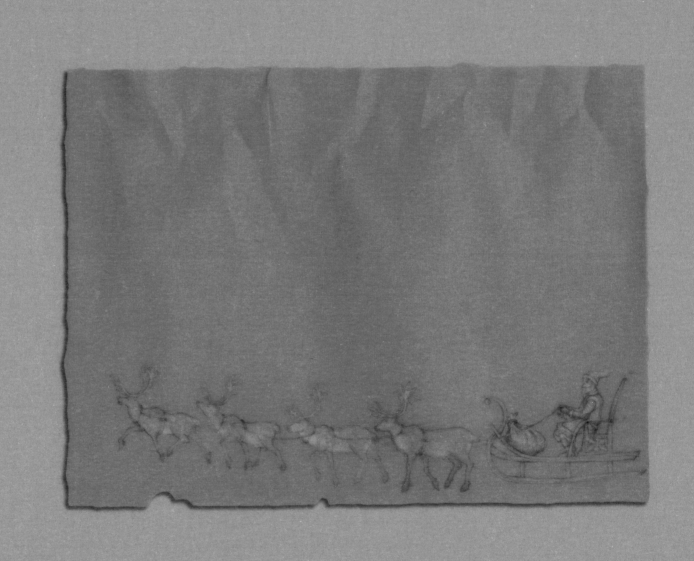

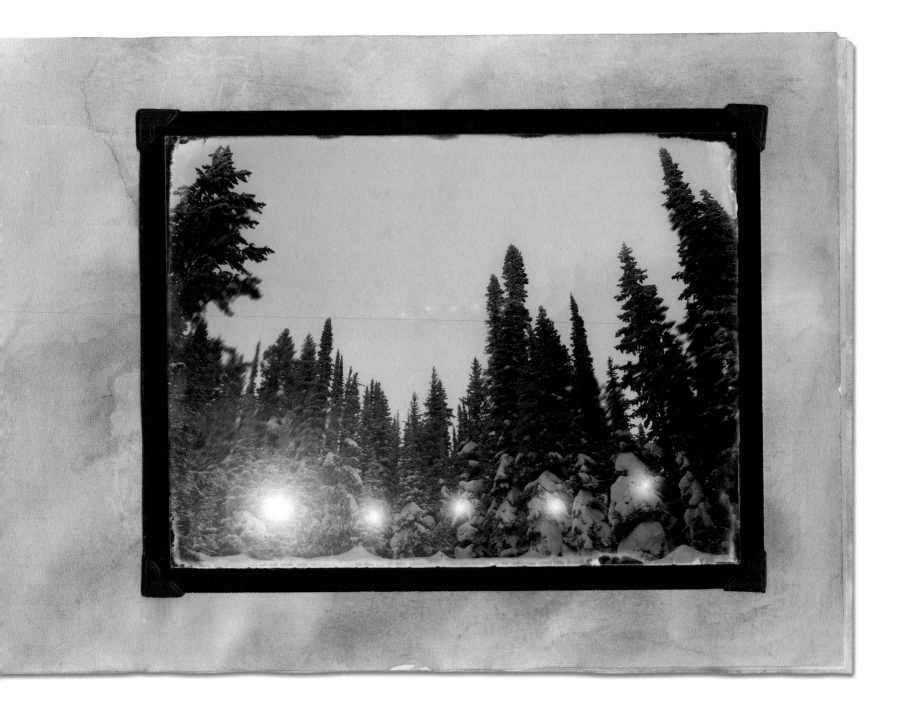

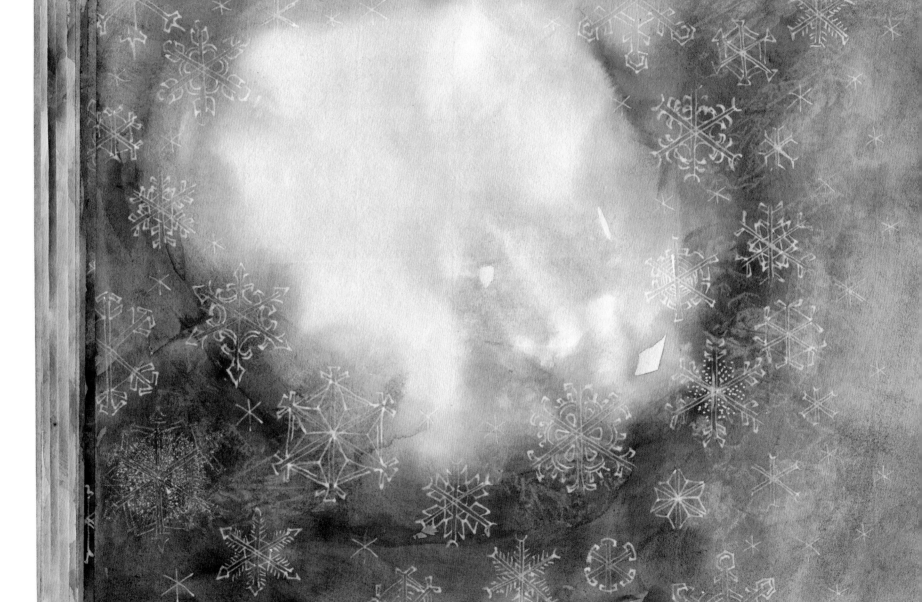

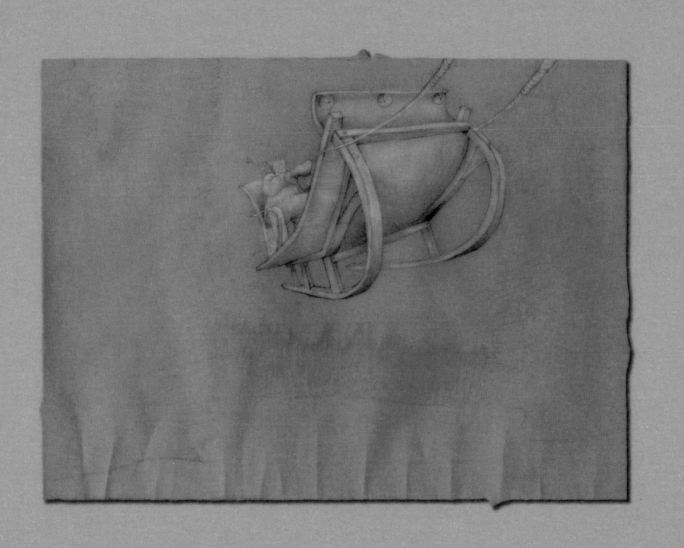

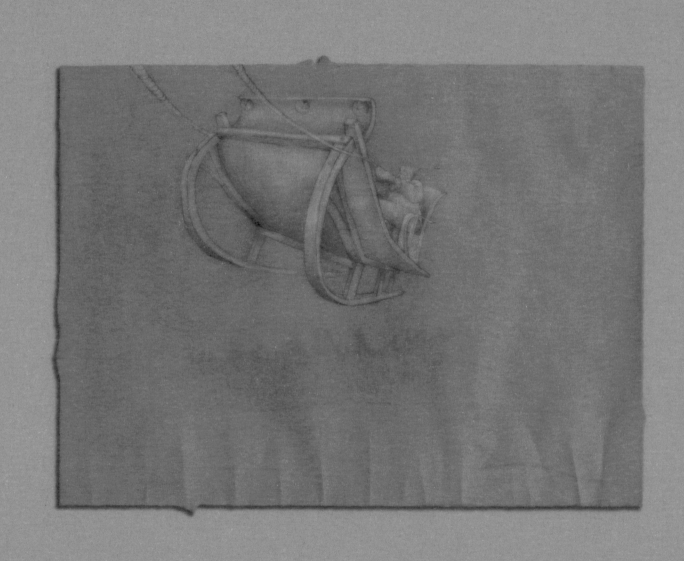

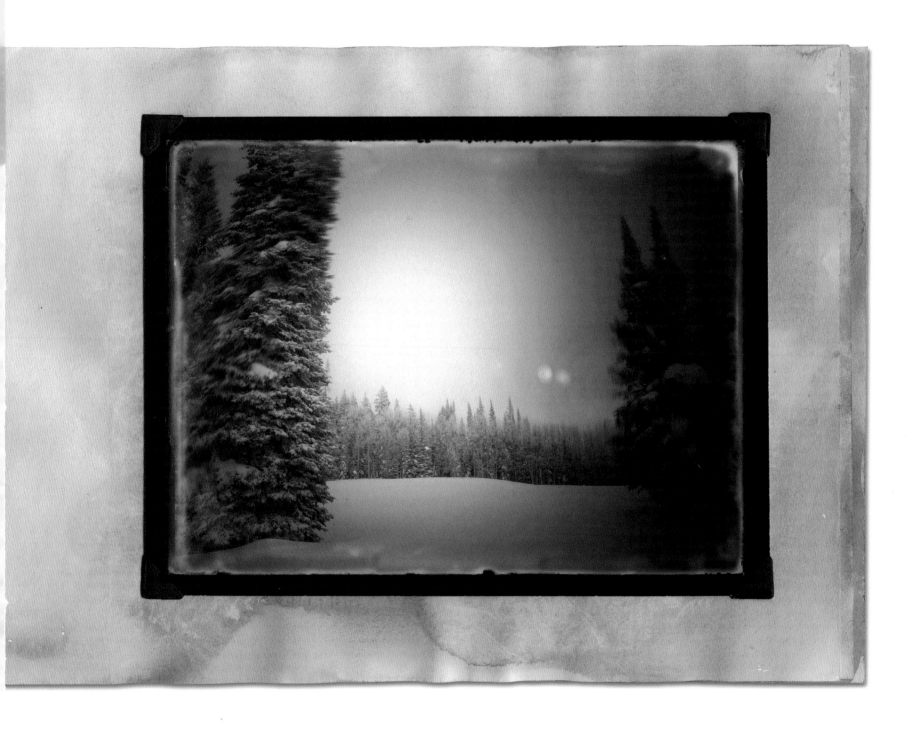

These drawings bring tears to my eyes. As I grew older the whole adventure seemed more a dream than anything else, for the curtains of time and memory folded over lived experience, making almost a fiction of it. Perhaps that's why Father and I never really spoke of all this later—it was so strange, even sacred— as though talking about it might have caused the whole story to unravel.

No longer. My father has saved this adventure from the vagaries of my deteriorating recollections, delivering it as bright and sure as the ringing of sleigh bells over distant hills.

Emerson's mother ran out to meet them, overjoyed and relieved. They told her about all that had happened: the blizzard, the mysterious stranger at their camp, the warmth of the fire, the skis and the reindeer and the sled. And then Emerson remembered: they never had found a Christmas tree. "I guess we'll have to do without one this year," he offered bravely. But his mom began to laugh. "Well, I don't know about that. Come and see!" Around the back of the house there was a beautiful blue spruce propped up against the mudroom wall. It was freshly cut and as full as it was tall. "The Christmas tree was here when I stepped out this morning," Mom said. "And I knew, somehow, that you two were going to be just fine."

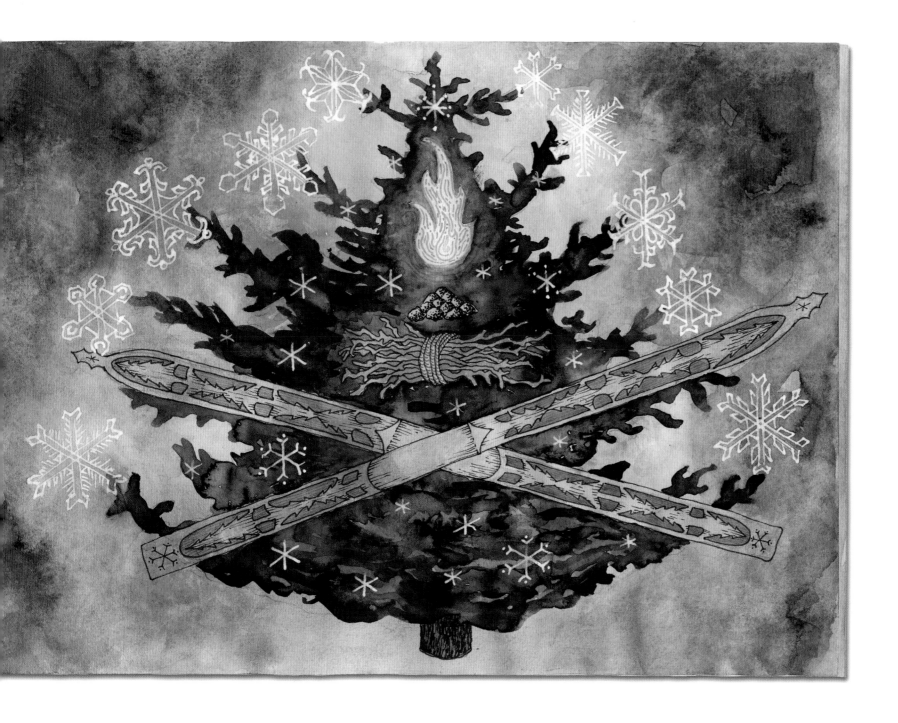

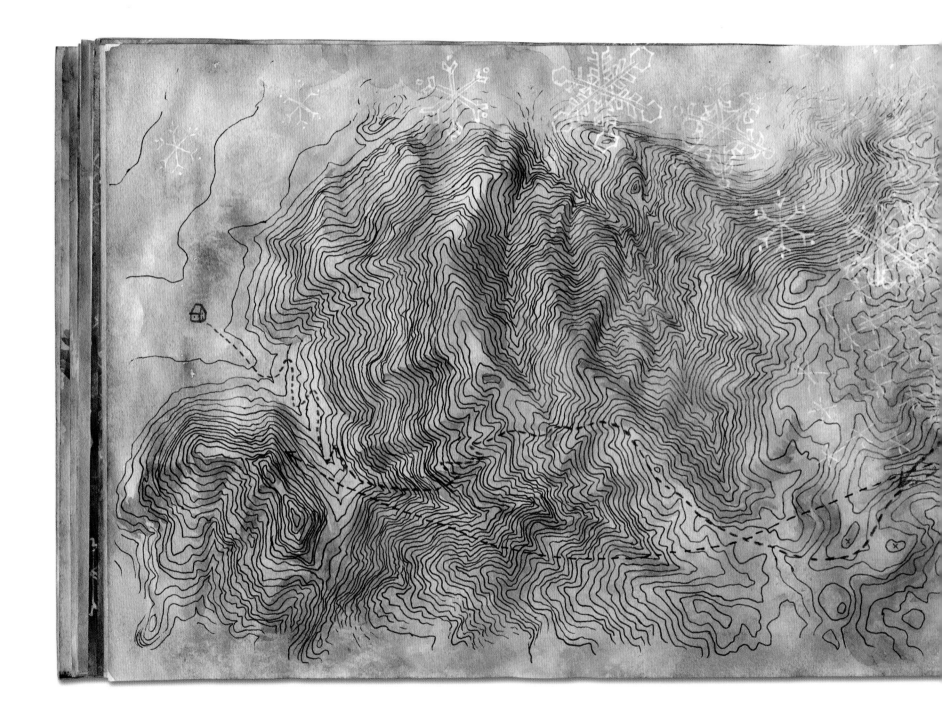

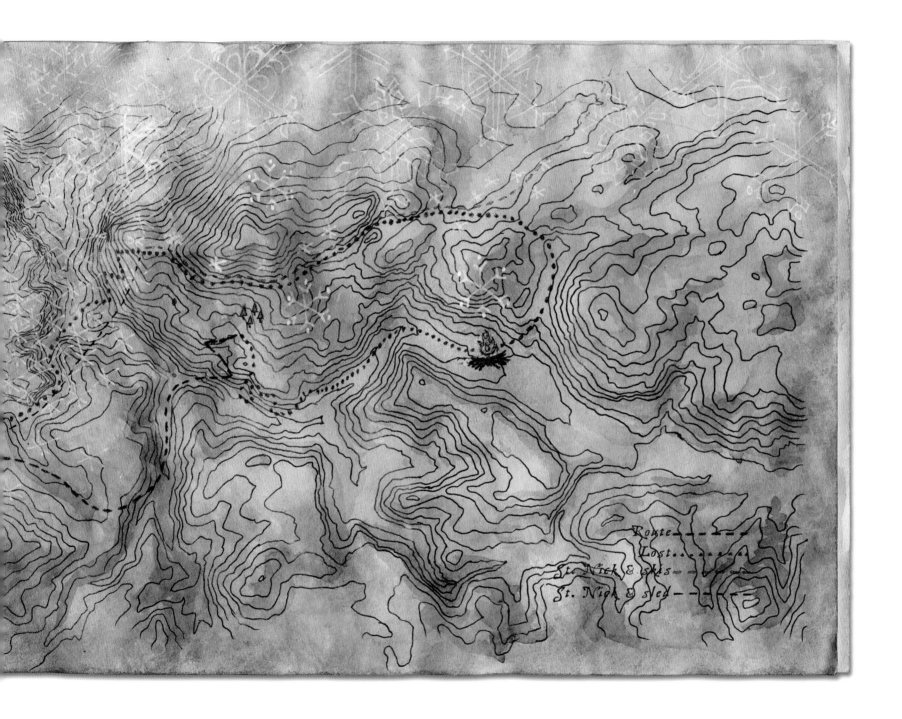

Route------·-·
Lost·······
St. Nick & skis— - —
St. Nick & sled— - —

My own children and grandchildren are grown now, and I am the great-grandfather of three little girls and one boy, who turned eleven back in October. They will all be arriving tomorrow, on Christmas Eve. The last Christmas gift I ever received from my father arrived late by seven decades, and just in time. Tomorrow I will share it with my family, and maybe take a walk with them in the woods, to look for a tree.

ACKNOWLEDGMENTS

This project was born on a frozen, snow-blown morning in 2003, when my wife Carol and I were skiing in the backcountry near Rabbit Ears Pass. The photographs I made that day made me think immediately of Saint Nicholas, a figure I have loved since childhood. It took another seven years for *The Lost Christmas Gift* to emerge out of those pictures. Along the way, my brother Bryan and my friend Michael Wolfe provided invaluable conversation and insights as the project took shape. Palden Renner helped me get St. Nick's body language and spirit down on paper. When the first draft of the project emerged, I sought advice from local friends in the publishing world. Without the critical feedback of Kae and Mark Penner-Howell, Coleen Hubbard and Larry Bograd, the final iteration of this book would never have been realized. Once it was, Jennifer and Kevin at Princeton Architectural Press believed in it from the first day they saw it, and have stood behind the project all the way to publication. As a first-time author, I am very fortunate to be represented by my agent Joanna Hurley, who has been a stellar guide and advocate. More broadly, my parents Pat and Wallace Beckham have believed in and supported my art-making for four decades now; I can only hope to do as much for the next generation of Beckham artists. Finally, I think perhaps the most potent force behind the creation of *The Lost Christmas Gift* has been my son Alden: this book is for him.